D1253395

NICK ROZSA

Portraits

Do You Remember Who You Really Are?
Interview with HeatherAsh Amara

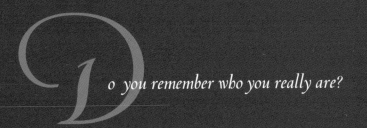

Do you remember who you really are?

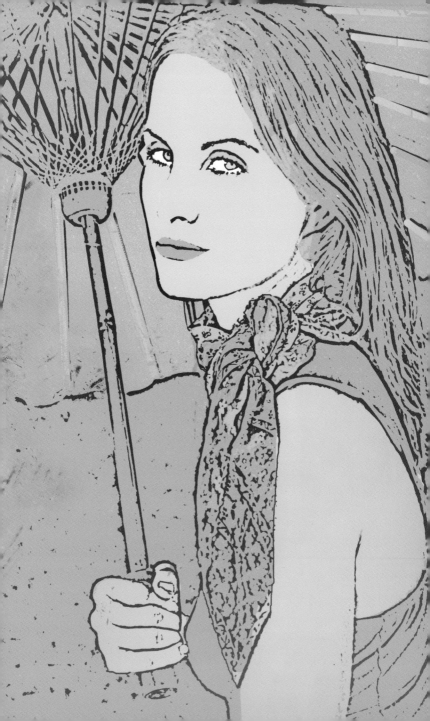

Do you remember who you were before you were born into this form and this body, when you were just a little light out in the Universe?

Before you met your parents...

Before you were indoctrinated and conditioned.

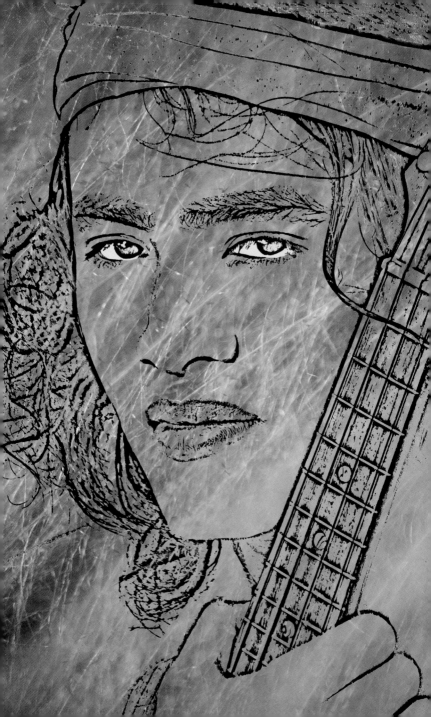

Who were you before you were limited by thought?

Can you remember your connection to a place of unlimited potential, unlimited possibility?

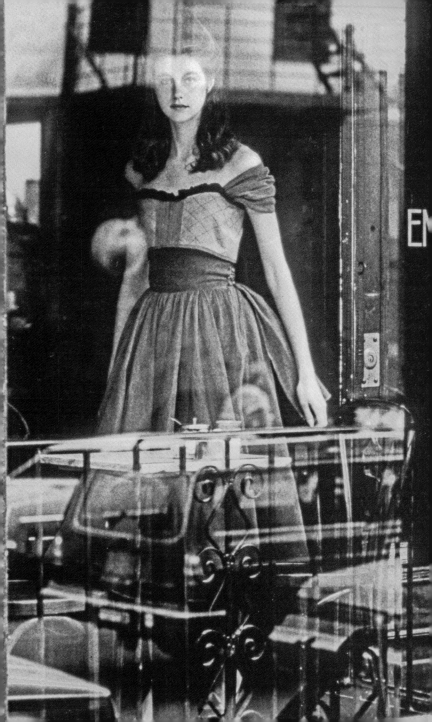

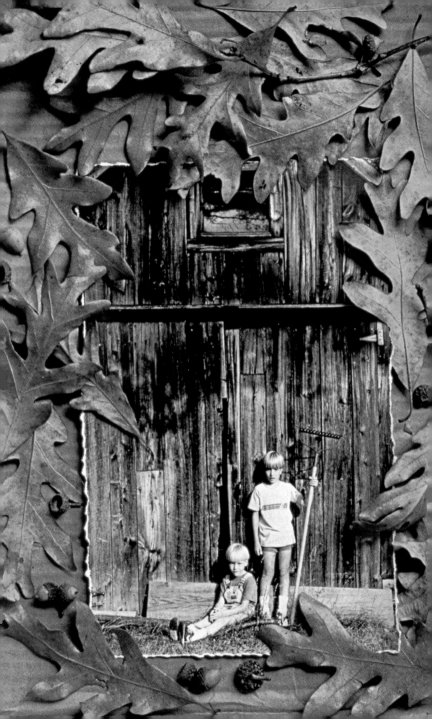

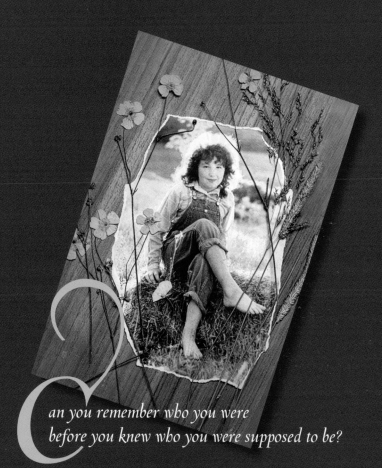

Can you remember who you were
before you knew who you were supposed to be?

Can you remember and bring those gifts all the way through your being and into this present form?

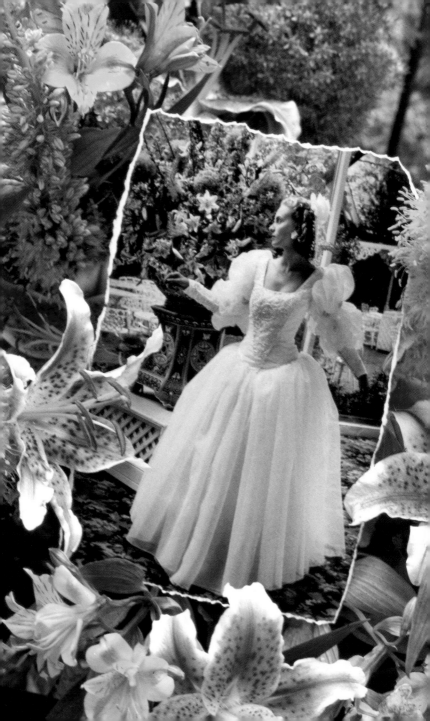

*Can you open to your creative passion and
the gifts that you are here to bring*

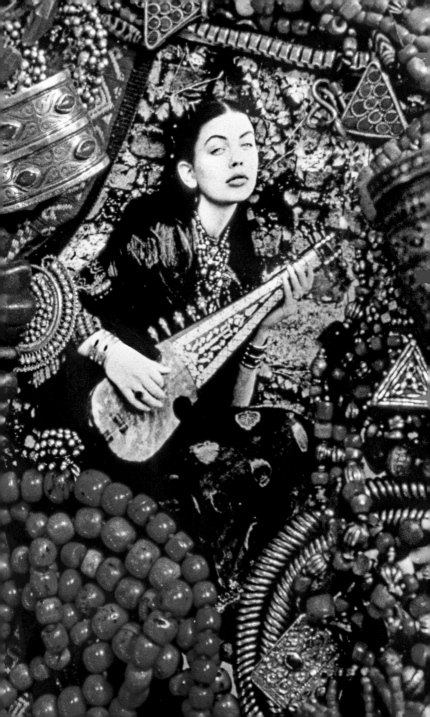

Can you feel what holds you back and limits you from that gift that you are?

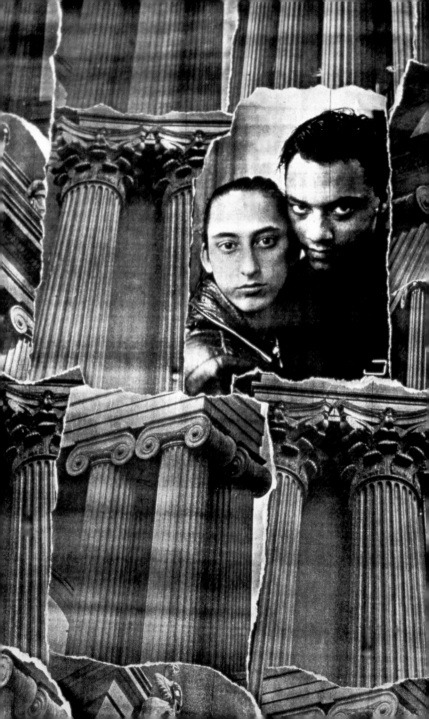

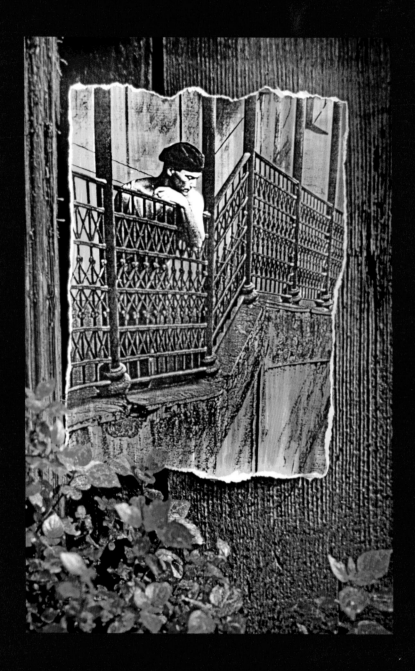

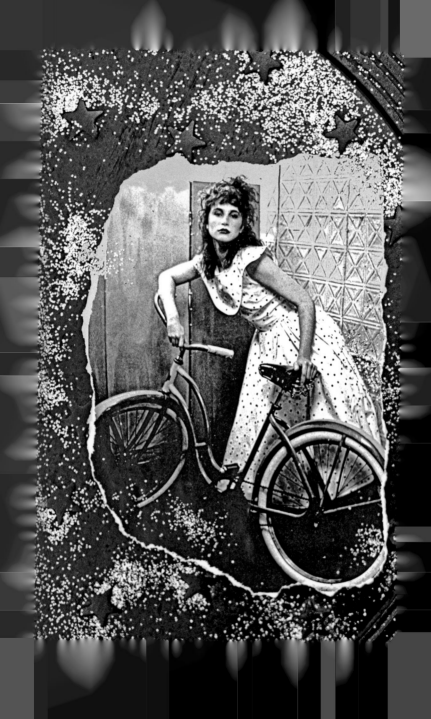

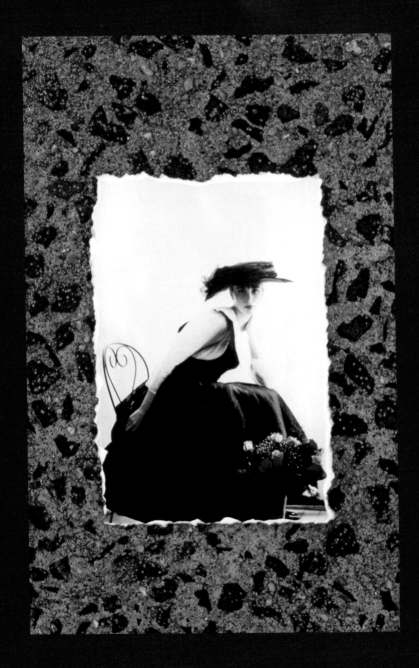

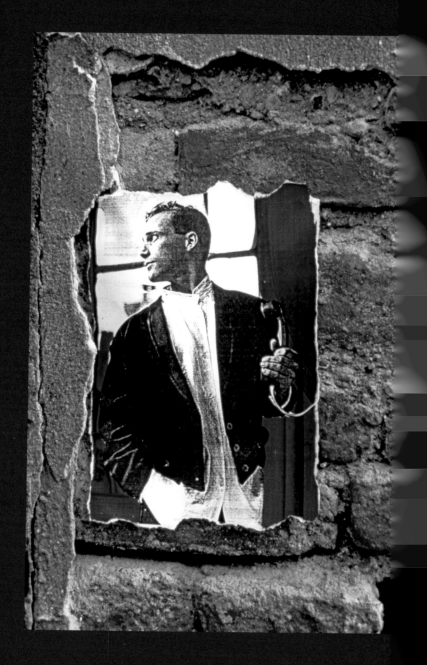

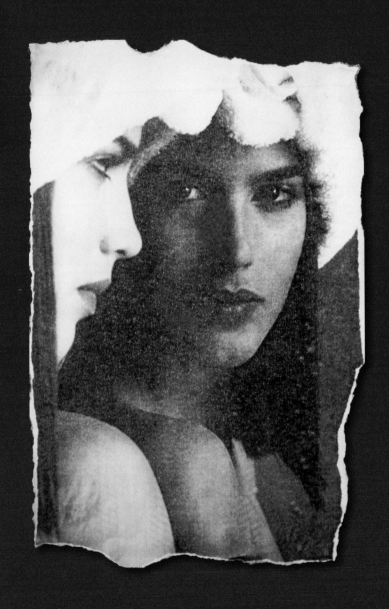

Please consider that it is your own thoughts and stories that keep you from being who you truly are.

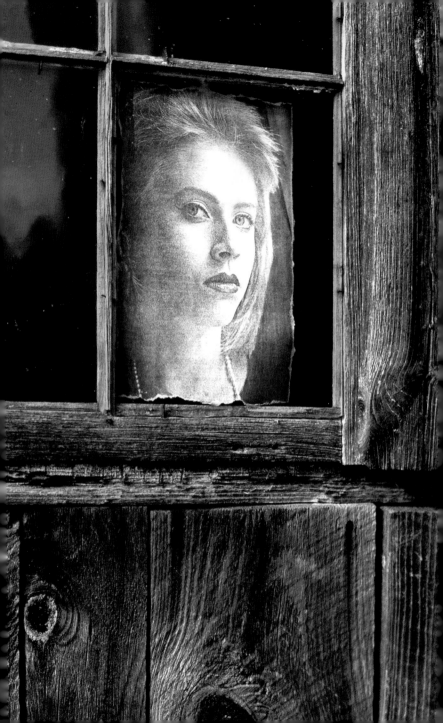

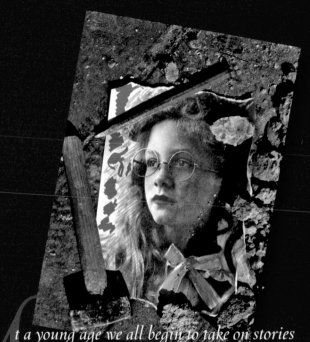

A t a young age we all begin to take on stories of who we should be. We model ourselves on the people around us and make ourselves smaller to fit in.

We get the message...

"Oh, you can't be that big.

You can't be that creative.

You can't be that wild."

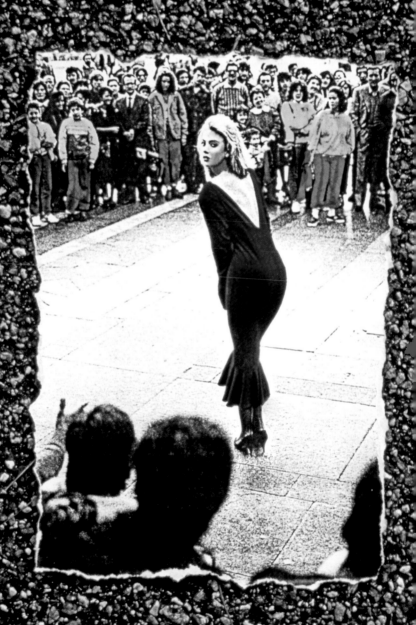

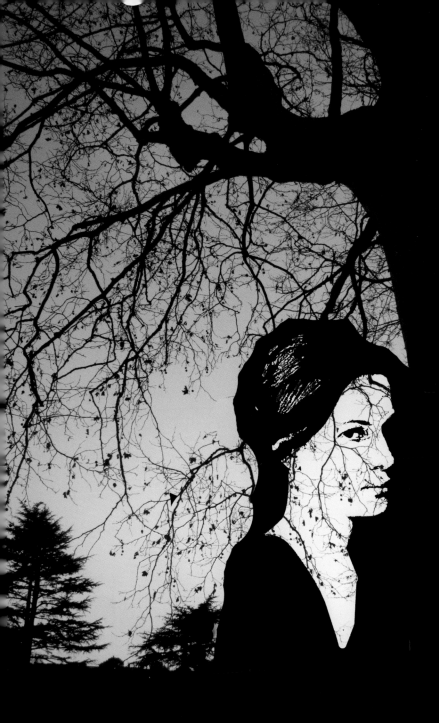

We start to get domesticated, and we domesticate ourselves. We take the wildness out.

We take the uniqueness out, we limit ourselves, we pretend to be something we are not, and we hide who we truly are because we become afraid of what others will think..

So many of us end up looking outside of ourselves, wondering, "Who am I supposed to be?" which immediately takes away the gift of who we are. Our authenticity gets lost.

If we look outside of ourselves, we may find places that inspire us, but the only place we're going to find "our" gift is by looking inside and by being really willing to make mistakes, to explore, to experiment, and to shine the light of who we are into the world.

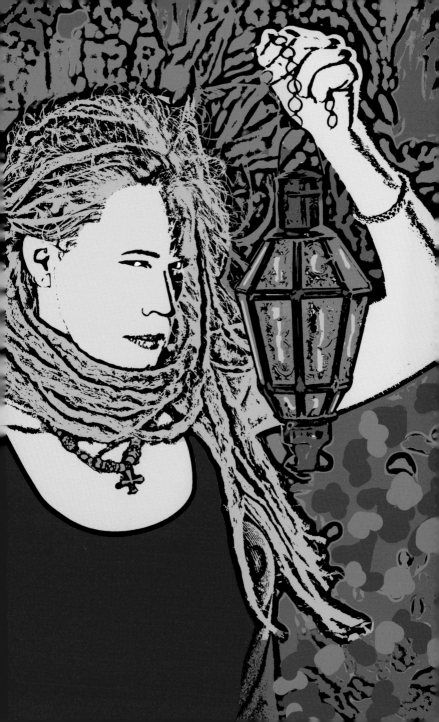

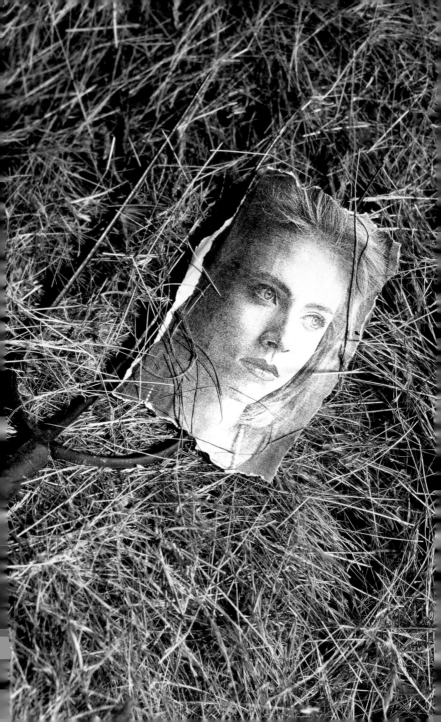

FEAR is the biggest factor stopping us from expressing who we truly are.

We fear that someone is going to judge us. We start to judge ourselves in anticipation of the perceived criticism that we imagine will be directed towards us.

Our need for approval traps our energy in questions like, "How do I fit in?" instead of, "Who am I?"

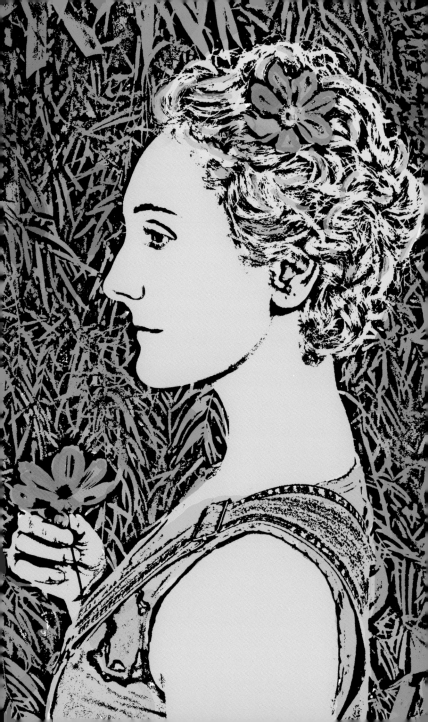

We are better served when we respect the creations that we bring into the world, whatever expression that is—whether it is our painting or writing or the way we communicate with other people or the way we live and think—that is our art, that is our gift.

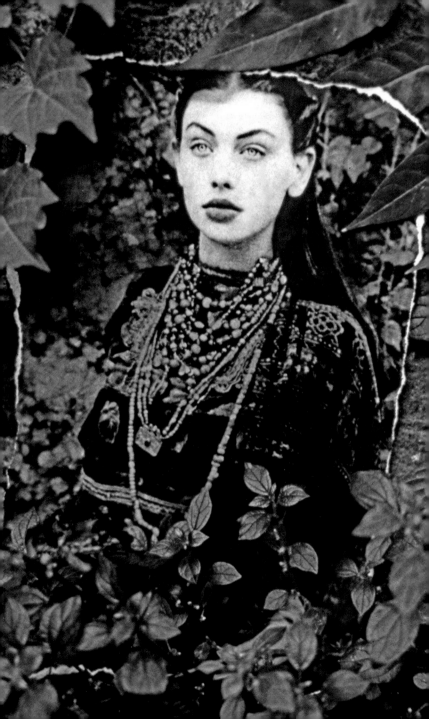

When we stop fearing judgment and stop judging ourselves, when we express ourselves honestly, fully and completely, by living more from our hearts, we will live a life that is truly rich.

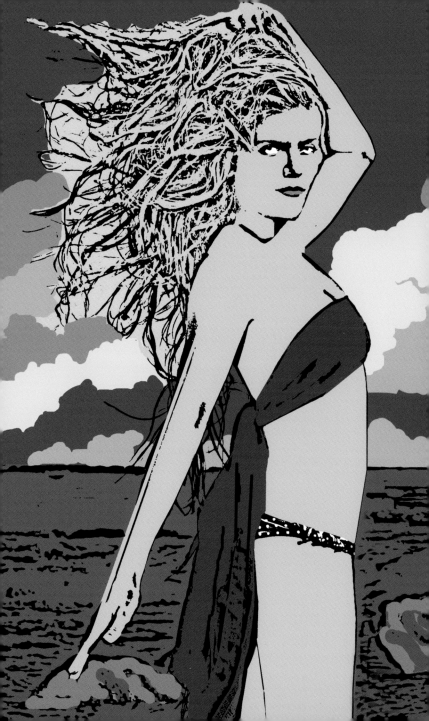

umans are one of the few species that take on self-limitation. It is so easy for flowers to bloom. They do not depend on each other's approval before they display themselves fully.

Let nature teach you about fearless self-expression.

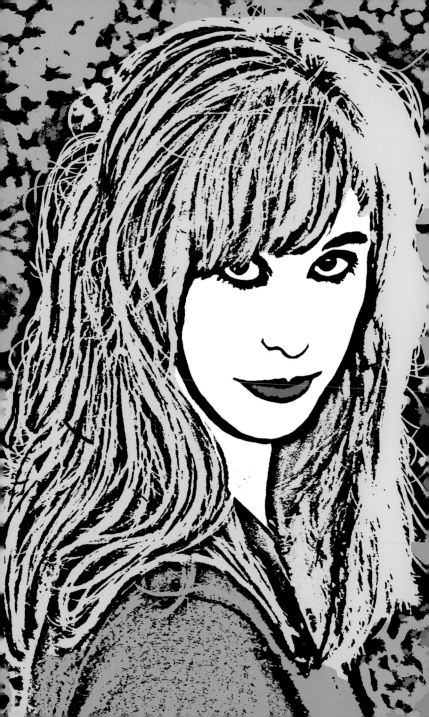

Initiation is a way to reclaim our authentic expression and honor our uniqueness and special connection to spirit.

A ritual or ceremony will help that really deep rewiring that we need in order to be ourselves.

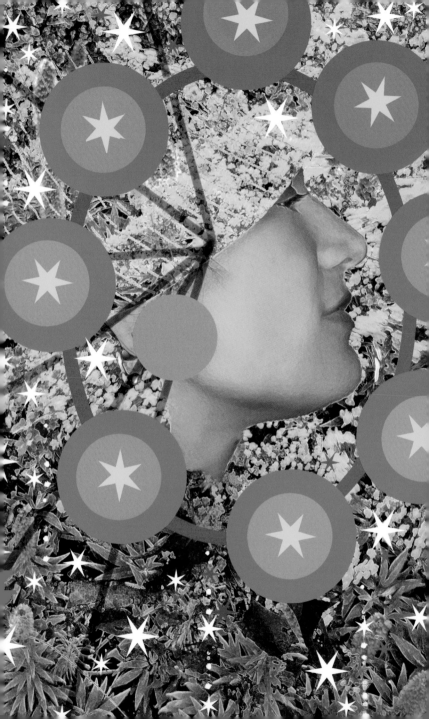

The beauty of initiation is that it works on a cellular level as we move from one phase of life to another.

It's the marker, it's the post that says we are passing from an old life into a new.

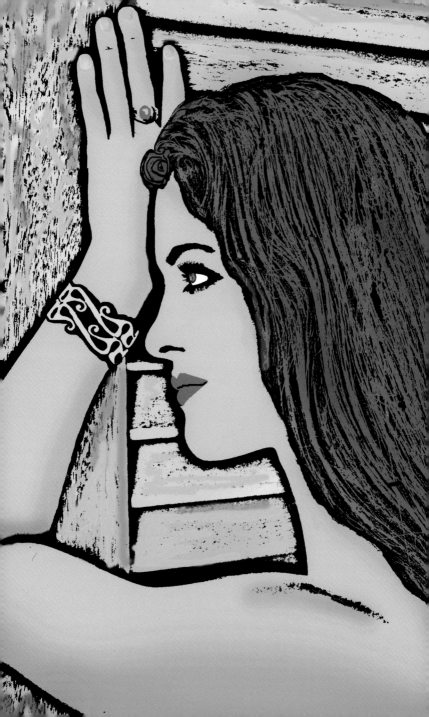

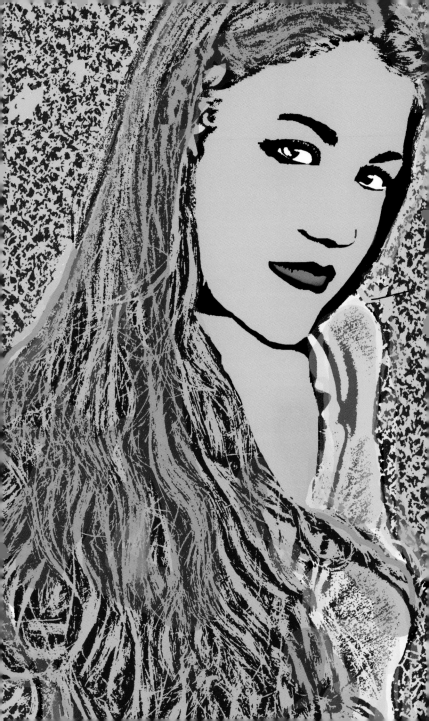

There needs to be willingness for things to be different and a willingness to take action.

A willingness to let go of the old story.

Start to investigate.

Be curious and recognize what you love
and what you are passionate about.

Connect to your instincts and let them
begin to guide you.

Seek out, and cultivate what inspires,
what creates passion and excites.

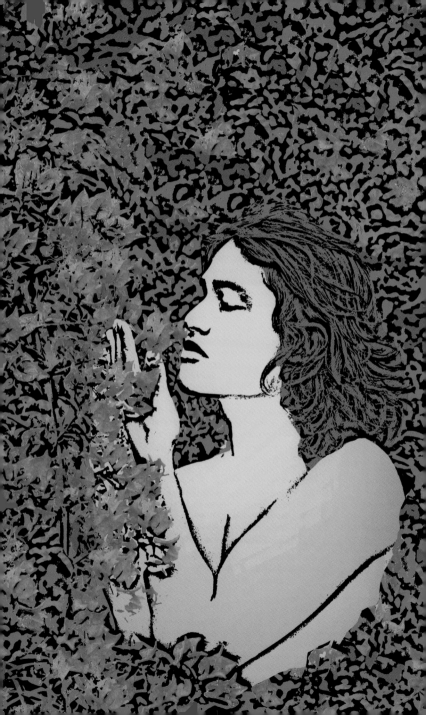

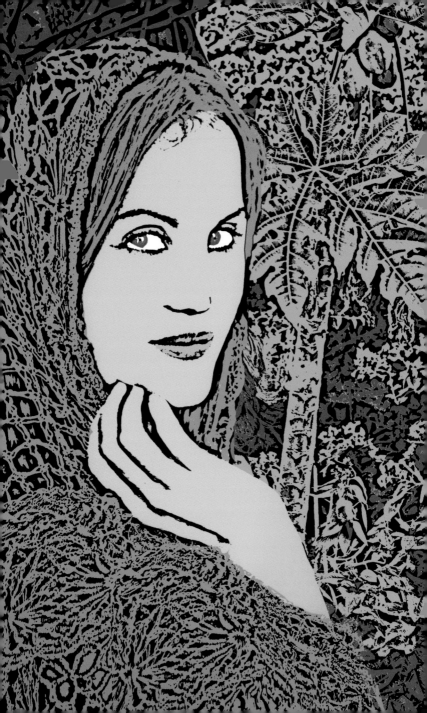

*B*eware of making self-limiting statements.

Every time we say, "I can't" or "I should"
we reinforce our imagined limitations.

Simply start talking in a different way,
stop judging and comparing. Instead,
trust and honor who you are and initiate
the process of full expression.

Be generous and share your gifts!

Let go of everything you've learned that is not you. Let go of all the fears and start again, towards your brightness and your truth. Initiate the unique precious being that you are, into this world.

Bring creation and creativity into your existence and honor yourself as an artist in all areas of your life.

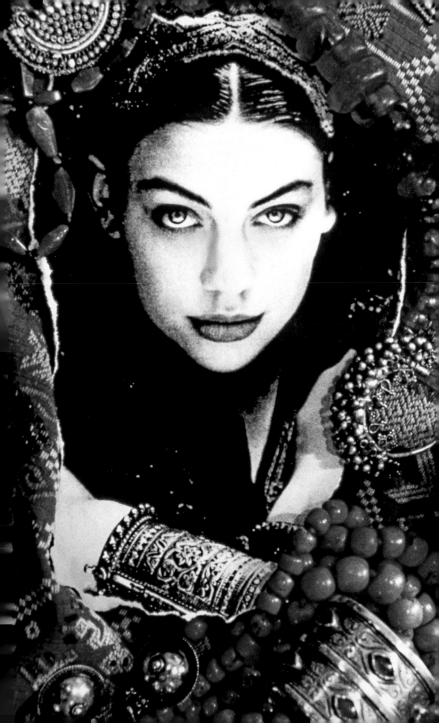

Remember who you really are.

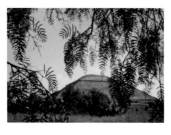

Nick Rozsa has traveled the globe producing photography and videos for several decades.

HeatherAsh Amara is an author and a spiritual integrity guide, leading and empowering groups over many continents. www.tolteccenter.org

I had the pleasure of attending an inspirational talk by HeatherAsh at the Pyramids of Teotihuacán in Mexico. She asked all of us in the group to wander around the Pyramids and come back with an answer to the question, "Can you remember who you are, and what you came here to do in this lifetime?"

I was reluctant to share my first thought, which I dismissed, in favor of what I imagined would be a more appropriate response. I felt compelled to say the right thing such as I have come here to be like Mother Teresa and help people in need, but when reporting back to the group, in truth, I could only return to my original thought.

I have come into this life to appreciate Beauty,
and encourage others to do the same.

—Nick Rozsa

*Special thanks to Anita Louise Rozsa
and to all my beautiful subjects.*

Published by:
DOGGY DREAMING PRESS
145 Town Center № 608
Corte Madera, CA 94925
www.doggydreamingpress.com
njrr@mac.com

No portion of this book can be reprinted without
written permission from the Publisher.

Printing by C&C Offset Printing Company, China
ISBN 978-0-615-34812-4

BOOK DESIGN BY JOHNATHAN COY, WWW.JMCOY.COM